Albrecht D

Victoria Salley

Prestel

Munich • Berlin • London • New York

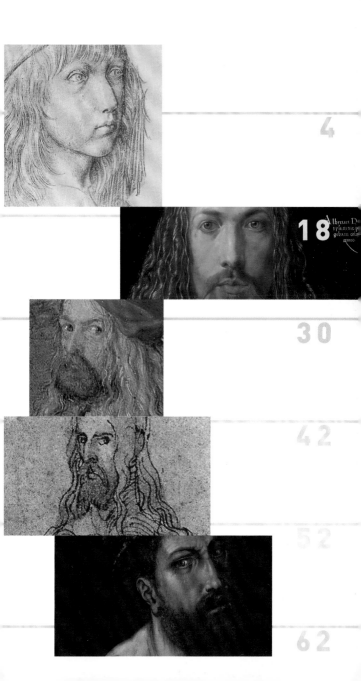

From Goldsmith to Painter

To call Albrecht Dürer a genius is certainly no exaggeration. Both from a technical standpoint and in its visual idiom, his work possesses a variety second to none and marks a turning point in art north of the Alps, for Dürer brought the art of the Renaissance to Germany.

Family origins and life in Nuremberg _ His diaries, letters and sketches as well as the family history he wrote breathe life into Dürer the man and the artist. His life began in Nuremberg, where his father, Albrecht Dürer the Elder, a Hungarian goldsmith, settled in the mid-1450s. His choice was a good one: Nuremberg was a Free Imperial City that had been an important trading centre since the thirteenth century, was known both for the superb craftsmanship and technical innovations that it produced, and was one of Europe's leading centres for the processing of precious metals.

In 1467, the goldsmith married his master's fifteen-year-old daughter, Barbara – the usual way to set up in business at the time. By marrying a master craftsman's widow or his daughter, a man became the owner of a workshop.

Childhood days _ Albrecht was born the third of eighteen children on 21 May 1471. A short while later, the family moved into one of Nuremberg's most exclusive districts, just below the castle. Albrecht Dürer the Younger was raised in an area where his godfather, Anton Koberger, the painter Michael Wolgemut, the publisher Hartmann Schedel as well as the patrician families of the Behaims, Scheurls and Pirckheimers made up part of the city's intellectual and artistic elite.

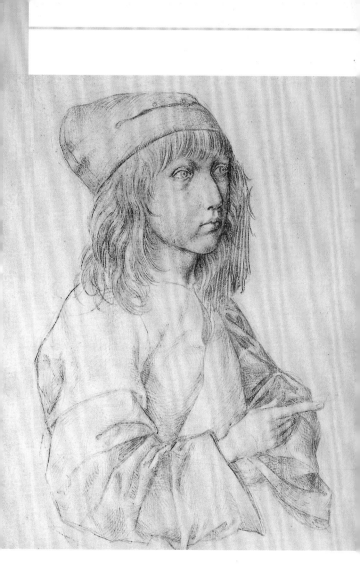

Dürers talent can already be seen at the young age of thirteen

Self-portrait, 1484, silverpoint, 27.5 × 19.6 cm, Albertina, Vienna

Michael Wolgemut and Wilhelm Pleydenwurff, **View of Nuremberg**, from Hartmann Schedel's **Chronicle of the World**, 1493, woodcut, 34.3 × 52.5 cm

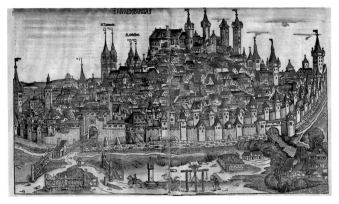

An apprenticeship as goldsmith _ In 1484, at the age of thirteen, he entered his father's workshop as an apprentice. That year he produced his earliest extant drawing, a self-portrait in silverpoint. Even if the portrait has some shortcomings, such as the oversized index finger, obvious corrections to its outlines and the awkwardly hidden hand, two things are immediately apparent: Dürer's unquestionable talent and his unusual interest in his own image. In the course of his life, he would paint more self-portraits than any other artist of his age. As a goldsmith mainly produces three-dimensional objects, the foundations

The Dürer Family Coat of Arms _

In 1523, Dürer designed a woodcut of his family's coat of arms. Already used by his father, the shield with its 'speaking' coat of arms and open door above the three-peaked hill refers to the family's origins in the Hungarian village of Ajtós near Gyula. When Albrecht Dürer the Elder reached Nuremberg in the 1450s, he appended the name of his place of birth to his Christian name, something that was then common practice. He translated the Hungarian word *ajtó*, signifying door (*Thür* in Old German). In the course of time, 'Thürer' became 'Dürer'.

Martin Schongauer (c. 1450–1491) _ The technique

of engraving, which as soon as it was developed rapidly spread across Europe, was closely associated with the artist Martin Schongauer. Originally used by goldsmiths in the production of pattern sheets, its economic potential was recognized by a resourceful artisan in the Upper Rhine area who began to produce engravings solely for printing and selling. Schongauer's engravings are characterized by detailed and masterly hatching which gave rise to a subtle gradation of tonal values and a textural representation of solid objects. His sheets greatly influenced stylistic developments, as they were used as models in the workshops of many late medieval painters.

were laid during Dürer's apprenticeship for his lifelong interest in achieving a clear sense of plasticity and his ability to portray objects and figures with a sense of depth on a flat surface. His early drawings clearly reveal that he was guided by work of Martin Schongauer.

> "*And now that I was able to produce neat work, my preference was more for painting than for the goldsmith's art. [...] And on St Andrew's day in the year 1486, my father promised to apprentice me to Michael Wohlgemuth to serve under him for three years.*"
> Albrecht Dürer, 1524

Presenting the Dürer family in the right light

Dürer Family Coat of Arms, 1523, woodcut,
33.5 × 26.6 cm

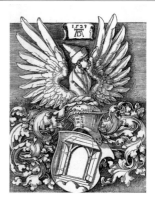

Michael Wolgemut (1434–1519) _ After marrying the widow of the painter Hans Pleydenwurff in 1472, Michael Wolgemut became the owner of a house with its own workshop. Working in the Netherlandish style, he ran the busiest painters' workshop in Nuremberg, although only a few works can be attributed to him with certainty. He was a pioneer of developments in the woodcut. Together with his son-in-law, Wilhelm Pleydenwurff, he produced illustrations for Hartmann Schedel's *Weltchronik*, among other books. Encompassing 2,000 sheets, it was the most comprehensive fifteenth-century book of woodcuts.

In Michael Wolgemut's workshop _ When he started his apprenticeship, Dürer was already fifteen – very old for the time. Little is known about the teaching methods at the end of the Middle Ages. For the most part, existing images were probably copied. Whether apprentices also drew from nature is a matter of speculation, as is the question of what tasks Dürer performed in the workshop of Michael Wolgemut, who, as a generalist, undertook a variety of large-scale commissions. Besides training him as a painter, it was the involvement of the Wolgemut workshop in the production of large series of woodcuts for book illustrations that most decisively influenced Dürer's development. Even if no creative traces of the young artist are

Dürer's teacher

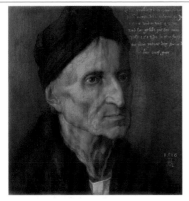

Michael Wolgemut, 1516,
panel, 29 × 27 cm, Bayerische
Staatsgemäldesammlung, Munich

The artist's parents

Barbara and Albrecht Dürer the Elder, 1490, panel, 47 × 38–39 cm, Galleria degli Uffizi, Florence, and Germanisches Nationalmuseum, Nuremberg

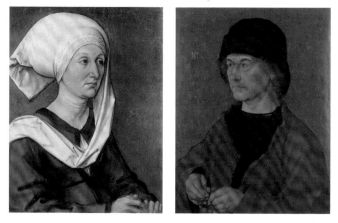

apparent in Hartmann Schedel's *Weltchronik* (Nuremberg Chronicle), for instance, it can be assumed that he was able to observe how such a major project was organized and turned into a financial success.

In the short time between the end of his apprenticeship and the start of his time as an itinerant journeyman after Easter 1490, Dürer painted the portrait diptych of his parents. The first sure evidence of his work as a painter, it shows that he had learned how to handle colour and that he was a keen observer. In its subtle characterization of his parents, it far exceeds the portraits produced in his teacher's workshop.

> *"And when I had served my time, my father sent me away until he called me back four years later."*
> Albrecht Dürer, 1524

Life as a journeyman _ As was customary, Dürer set off in 1490 to broaden his knowledge. His destination was the workshop of the famed painter and printmaker Martin Schongauer in Colmar. To this day, nothing is known about the first two years of Dürer's travels. Only with his arrival in Colmar in 1492 do we again have concrete evidence relating to him. And how disappointed he must have been, for Schongauer, much admired by Dürer, had died only a short time

St Jerome Pulling a Thorn from a Lion's Paw, 1492, coloured woodcut, 19.2 × 13.5 cm

My Agnes (Portrait of Agnes Frey), 1494, pen and ink, 15.6 × 9.8 cm, Albertina, Vienna

before. Dürer soon moved on, but spent another two years in the Upper Rhine area, which, for the preceding fifty years – together with Flanders and Burgundy – had been *the* cultural hub of Europe north of the Alps.

First success with book illustrations _ In summer 1492, he is known to have been in Basle, where he earned a living producing woodcuts for book illustrations. The earliest documentary proof is the frontispiece of an edition of St Jerome's letters; its printing block – now held in Basle's Collection of Prints and Drawings – was confidently signed by the artist on the reverse: "Albrecht Dürer von nörmergk". It is notable for its wealth of realistic detail in the interior, where the perspective is rendered slightly amiss, however. Such attention to detail was to remain typical of Dürer's work and in his later woodcut series the *Life of the Virgin* he would achieve a particularly intimate quality by such means. Having thus demonstrated his skills as an illustrator, he received further commissions, including one to illustrate a book of stories entitled *Der Ritter vom Turn* (The Knight of Turn), a devotional text printed in Basle in 1493 and typical of its age. A year later, he produced illustrations for Sebastian Brant's *Narrenschiff* (Ship of Fools). From Basle, Dürer moved on to Strasbourg, where he worked as an illustrator and painter, too.

Return to Nuremberg and marriage _ In spring 1494, Dürer returned home to Nuremberg at the request of his father, who had arranged his son's marriage to Agnes Frey, the daughter of a wealthy merchant. The ceremony was held on 7 July 1494. Yet soon after, in autumn that year, the young man set off again, this time heading south, but without his wife and seemingly without having made any efforts at setting up a marital home. Was this a reaction to the outbreak of the plague in Nuremberg? Or did he want to continue to develop his skills in Italy? Whatever his reason, his behaviour has led scholars to speculate about the depth of feeling between the newly-weds – it was an arranged marriage, after all.

Journey to Venice _ Dürer left no written record of the route he took or of his stay in Venice, but his journey can largely be reconstructed using the fifteen or so sketches he made of the towns and landscapes through which he passed on his way to Italy via Innsbruck and Lake Garda. Dürer's work from 1494–95 clearly shows how his artistic development received a new impetus through his encounter with Italian art. The paintings of Giovanni Bellini, the greatest artist then in Venice, made a lasting impression on him. Moreover, he examined Andrea Mantegna's and Leonardo da Vinci's anatomical studies of the human body and learned how to reproduce the natural world using gradations of colour. He had finally connected with the art of Italy!

Opening of own workshop _ After his return to Nuremberg in 1495, Dürer opened his own workshop, which at first specialized in graphic art, probably because it promised quicker financial rewards. Around this time, he again turned his hand to engraving and produced work on

One of the places Dürer visited on his trip to Italy

Arco, 1495, watercolour and opaque colour, 22.1 × 22.1 cm, Musée du Louvre, Paris

Four Witches, 1497, engraving, 19.1 × 13.4 cm

Elsbeth Tucher, 1499, limewood, 29 × 23.3 cm, Gemäldegalerie Alte Meister, Kassel

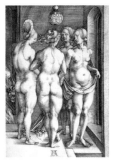 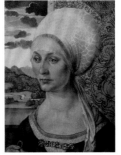

mythological and allegorical subjects that, because they were not readily intelligible, were intended for a small, educated circle of buyers; besides, engravings were more expensive than woodcuts. The female nudes in engravings such as *Four Witches* of 1497 or *The Doctor's Dream* of *c.* 1498 reveal the influence of Italian and antique models on Dürer's articulation of the volumes and proportions of the naked body.

First commissions from Frederick the Wise _ The range of Dürer's work expanded to include large-scale painting commissions. His first was received from Frederick III (the Wise), the Elector of Saxony, who had his portrait painted when he visited Nuremberg in April 1496. At the same time, he commissioned a large altarpiece of the Virgin, the so-called *Dresden Altarpiece*, of which only the panels with the *Seven Sorrows of the Virgin* have survived. Nuremberg's patricians and merchants followed the Elector's example and commissioned works from Dürer. In addition to altarpieces, such as the *Paumgartner Altarpiece* of *c.* 1498, he mainly produced portraits of the city's wealthy citizens. The most celebrated portrait is surely that of Elsbeth Tucher of 1499, which graced the twenty-mark note until the introduction of the euro. His self-portrait of 1498 and the portrait of his father of 1497 clearly mark the culmination of his skill as a portraitist, however. Here he was able to take artistic liberties, without having to take a client's demands into account. In the portrait of his father, for instance, he dispensed with all superfluities and concentrated on the face. In doing so, he took an enormous step as a por-

Young and old – the gentleman and a character study

Albrecht Dürer the Younger, 1498, panel, 52 × 41 cm, Museo Nacional del Prado, Madrid
Albrecht Dürer the Elder, 1497, limewood, 51 × 39.7 cm, National Gallery, London

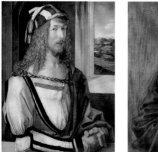

traitist: rather than identifying the sitter by means of a similarity in appearance, Dürer succeeded in conveying his father's personality.

International success with the Apocalypse _ Up until 1500, Dürer's greatest achievement in his graphic art was undoubtedly his large *Apocalypse* series, which he published himself two years before the millennium, when the end of the world was widely thought to be nigh. Addressed to the world in general, the *Apocalypse* woodcuts are impressive because of their subtlety of technique, sheer scale and drama, and they established Dürer's fame throughout central Europe. Even the great Raphael consulted them when producing his frescos in the Vatican.

Prophesying the end of the world – a picture of horror leads to success

Four Horsemen of the Apocalypse, *c.* 1497/98, woodcut, 39.6 × 28.3 cm

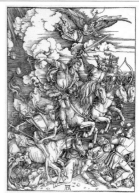

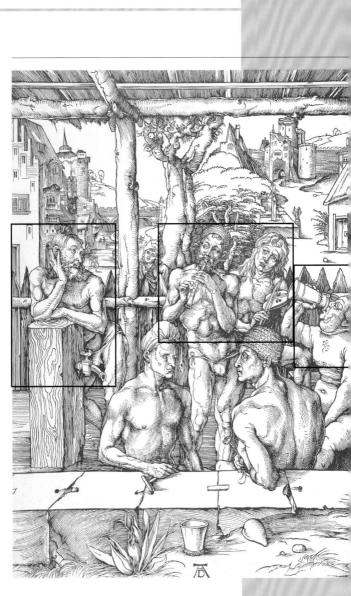

Men's Bathhouse, *c.* 1496/97, woodcut, 39.4 × 28.4 cm

Men's Bathhouse

When the senses take a plunge _ Dürer's examination of the human body

Dürer's enhancement of the status of the woodcut was one of his greatest achievements. Numbers alone indicate his interest in this form of graphic art – and he produced many more woodcuts than engravings and etchings. His woodcuts were usually combined with texts – either in pamphlets or as illustrations in books. Dürer strove to lend the image greater importance and placed his full-page woodcuts alongside the text as its equal. He also produced individual woodcuts without any text at all – such as *Men's Bathhouse*.

In close proximity to the viewer, six men of different ages and builds are shown in an open-air bathhouse made of timber. In the background, we see a castle perched atop a hill, overlooking a town. A young man observes the bathers across a fence that provides a visual barrier between the bathhouse and the town. His gaze meets that of the viewer, making a voyeur of him, too. In the Middle Ages, there was nothing unusual about visiting public bathhouses, as not everyone could afford their own washing facilities. Apart from being places where personal grooming was done, they were also meeting points and places of entertainment in the widest sense. Bathhouses bore the stamp of eroticism, and so it is hardly surprising that they were subject to strict regulations and supervision. Dürer's *Men's Bathhouse* and *Women's Bathhouse*, produced at roughly the same time, accurately portray the bathhouse and bathing practices, such as the straw bathing hats and segregation of the sexes; nevertheless, his prints are far more than genre scenes, although contemporary sources confirm that visitors to public bathhouses wore bathing shirts.

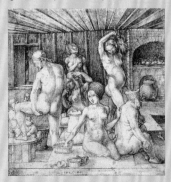

Women's Bathhouse, c. 1496, pen-and-ink drawing, 23.1 × 22.6 cm, Kunsthalle, Bremen

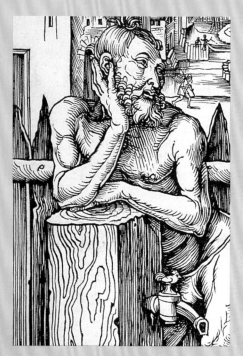

Dürer's fascination with the human body led him to depict his bathers nude. "Contours and modelling are exaggerated, planes fluctuate – yet such exaggeration was necessary for the drawing to express the whole force of sensuous perception, of the experience of form." (Heinrich Wölfflin, 1905) Neither did he shy away from an earthy erotic allusion: it is no coincidence that the tap juts out of the well post just in line with the genitals of the bather standing contemplatively in his undergarment.

Given that this is no genre scene, but is clearly a picture puzzle laden with meaning, scholars have sought to uncover its secrets. The bathers are drawn in such a way that they look like individuals and tempt one time and again to see in them men from Dürer's circle of friends. The corpulent drinker is said to be Willibald Pirckheimer; in the observer standing by the well post others see a portrait of Dürer himself. None of these figures looks like these men in known portraits, however.

Another hypothesis would have the bathers represent the five senses: the two men at the front, one with a scraper and the other holding a carnation, personify touch and smell; the portly drinker personifies taste, while the musicians personify hearing. Standing slightly to the side, the man observing the group personifies sight.

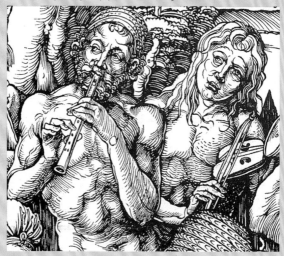

On the other hand, the distinctly stylised figures may be understood as personifications of the four cardinal humours. Since Antiquity, it had been believed that four bodily fluids determine a person's physical and mental qualities. In the ideal person, their proportions were thought to be equal; in ordinary folk, however, they were unequal. The sanguine type, in this case the bather holding the carnation, has too much red blood; the portly phlegmatic type – here, the drinker – possesses too much phlegm. Too much yellow bile is characteristic of the volatile choleric type, seen here in the man with the scraper; and too much black bile is responsible for the despondent character of the melan-cholic type, perceived here to be the man standing contemplatively.

Even if a specific meaning cannot be attributed to every figure and object, it is not entirely wrong to see a connection with the tempera-ments and the five senses given that the theory of the cardinal humours was of topical interest to humanist scholars of the day.

The Master of his Craft

Philosophy enters Dürer's thinking _ Searching for ideal human
proportions and the right perspective _ The workshop expands _
Second journey to Italy: celebrations in Venice and recognition as
an artist _ Return to Nuremberg

Philosophy enters Dürer's thinking _ Even if many people saw
portents of apocalyptic plagues in recurring epidemics and the threat
of a Turkish invasion, not everybody believed the end of the world
was nigh. The humanist and poet Conrad Celtis, a friend of Dürer's,
believed on the contrary that with the reign of Maximilian I a Golden
Age was about to dawn, one based on an idealized image of man.

Such was the context in 1500 when Dürer – aged twenty-nine –
produced his self-portrait, marking a new stage in his creative output.
With this Christ-like image, he lent new significance to the self-por-
trait, although it should not be misinterpreted as presumptuousness or
an expression of Dürer's inflated view of himself. The resemblance can
instead be ascribed to Marsilio Ficino's theory that describes Man as
the pinnacle of creation because his creative abilities make him similar
to the 'divine artist'. It was his humanist friends Celtis and Pirckhei-
mer who awoke Dürer's interest in this Italian philosopher's teachings
which must have corresponded to his conception of himself as an artist.

At the same time, Dürer began to approach art from a theoretical
stance, too. He endeavoured to discover the compositional principles
that enabled Italians to depict their figures with the beauty and natur-
alistic accuracy of works of Classical Antiquity. According to Jacopo
de' Barbari, whom Dürer had met in Venice, the fundamental princi-
ples of art were geometry and arithmetic. Only through art based on
mathematical principles was it possible to recognize the nature of
things. The logical conclusion to be drawn from this – one that was also
revolutionary for the guilds of the day – was that painting should no
longer be regarded as one of the *artes mechanicae*, the trades, but as
one of the artes *liberales*, geometry and arithmetic among them. In
Germany around 1500, however, such thinking was a distant prospect.

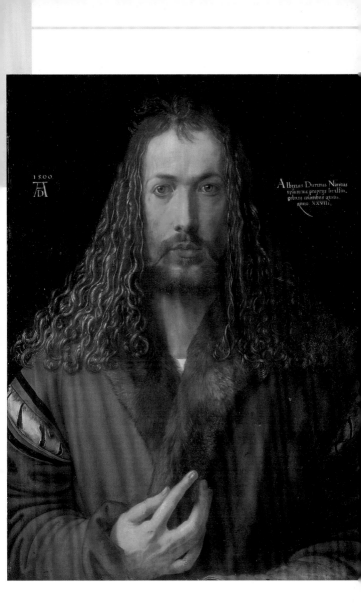

Dürer's self-confidence grows

Self-portrait, 1500, limewood, 67 × 49 cm, Bayerische Staatsgemäldesammlungen, Munich

Searching for ideal human proportions and the right perspective _ On his return from Venice, Dürer began intensive studies of the ideal proportions of the human body and of perspective to allow him to achieve harmony in his compositions. He produced countless nude drawings and engravings, such as *Apollo*, whose proverbial beauty Dürer expressed in the force of his drawing, or his engraving of the Greek goddess of retribution, *Nemesis* which, even if its subject

Still searching for the ideal human form ...

Apollo, *c.* 1500, pen and ink, 28.3 × 20.5 cm, British Museum, London
Nemesis (Large Fortune), *c.* 1501, engraving, 33.5 × 26 cm

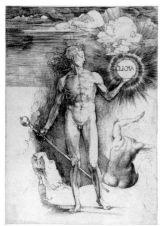
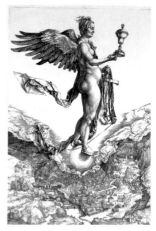

... Dürer refines his technique

Adam and Eve, 1504, engraving, 25.1 × 19 cm

St Eustace, 1501, engraving, 35.6 × 26 cm

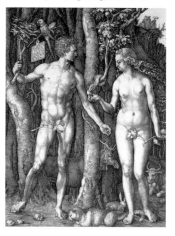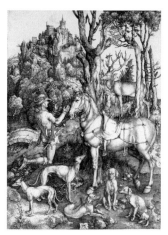

now appears rather crude and ungainly, was based on a proportional scheme. His examination of the ideal human figure culminated in 1504 in his engraving of Adam and Eve, which was a variation on such Classical sculptures as *Apollo of Belvedere and Medici Venus*. Aware of his achievement, he added his signature and monogram to the engraving on a small, prominently placed plaque. At the same time, he also devoted himself to producing an ideal image of the horse. He turned to theoretical treatises as well as to real models, such as the renowned antique horses of St Mark's in Venice or Andrea del Verrocchio's equestrian statue of Bartolomeo Colleoni that was erected in 1488 and which Dürer saw when he visited that city. The engraving depicting the legend of St Eustace is one of the earliest examples of the quest for ideal equine proportions, but not only that. Just as clearly, it is proof of another of Dürer's approaches to his work: the hounds in the hunter's pack, shown in various attitudes, were preceded by numerous life studies.

> "For, verily, art is embedded in nature; whoever can draw her out, has her..."
>
> Albrecht Dürer, *Vier Bücher von menschlicher Proportion*, 1528

The animal and plant studies that he executed around this time, such as the famous *Hare* or *Large Piece of Turf*, reveal a naturalism and ease that give the impression the artist was looking for a change from his theoretical studies – something that gave free reign to his skill, something that enabled him to shake off the shackles of composition.

Nature is the best teacher

Large Piece of Turf, 1503, watercolour and opaque colour on parchment, brush and pen, heightened in white, 40.3 × 31.1 cm, Albertina, Vienna

Hare, 1502, watercolour and opaque on paper, brush, heightened in white, 25 × 22.5 cm, Albertina, Vienna

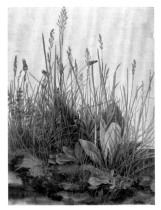 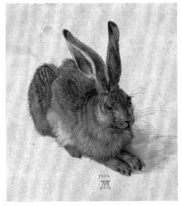

They are now among the most famous works by Dürer to have survived, although for him they were always studies. Their fascination lies both in the virtuosity of the brushwork or pencil markings as well as their directness: no wood engraver, printer or apprentice stands between the artist and the viewer.

The workshop expands _ Dürer in the meantime had established a good business. Faced with a large number of orders on his books, mainly for illustrations and stained-glass designs, and because of his

Dürer shows his expertise in his large alterpieces

Glimm's Lamentation of Christ, *c.* 1500, spruce, 151.9 × 121.6 cm, Bayerische Staatsgemälde-sammlungen, Munich

Adoration of the Magi, 1504, panel, 100 × 114 cm, Galleria degli Uffizi, Florence

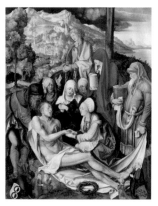 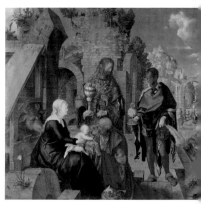

own time-consuming theoretical studies, he had to hire assistants. He succeeded in engaging the best journeymen of his day: Hans Süss von Kulmbach, Hans Baldung, called Grien, and Hans Schäufelein. Each was able to develop his own particular style within Dürer's workshop, something that was rather remarkable and none too common. This was possibly a reaction to his own years as a journeyman that he described as unpleasant in his family history, but it is also certainly due to Dürer's humanist interests. Large paintings, such as Holzschuher's *Peasants' Revolt* and Glimm's *Lamentation of Christ*, both of *c.* 1500, he probably executed himself to satisfy the demands of his clients. The same is true of the *Adoration of the Magi*, a 1504 commission from Frederick the Wise.

Giovanni Bellini (c. 1430–1516)

was the leading artist in Venice during the transition from the early to the High Renaissance. With his glowing palette and its atmospheric effects, he founded the Venetian school of painting, in which colour and light were the primary means of expression. Dürer wished to be acknowledged by this highly respected man – and succeeded in his wish. Bellini visited him in his Venice studio. It is said that during this legendary meeting Bellini was keen to acquire the brush Dürer used to draw hair. After examining it, however, he had to acknowledge that the fineness of the Nuremberger's drawings could not be attributed to the tool, but only to his skill.

Second journey to Italy: celebrations in Venice and recognition as an artist _ In 1505, Dürer travelled to Italy for a second time, and again he set off just as the plague broke out in Nuremberg. We are well informed about his life in Venice on this occasion thanks to his correspondence with Pirckheimer. In contrast to his first stay there, he was no longer unknown. The artists of Venice did not at first give him a friendly reception, however. He complained to Pirckheimer that they

With this painting Dürer reached fame in Venice ...

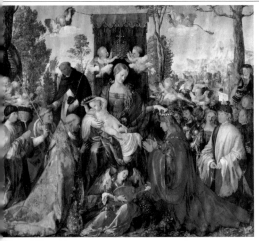

Feast of the Rose Garlands, 1506, poplar wood, 162 × 194.5 cm, National Gallery, Prague

... and became a sought-after portraitist

Portrait of a Young Venetian Woman,
1505, elmwood, 32.5 × 24.5 cm,
Kunsthistorisches Museum, Vienna

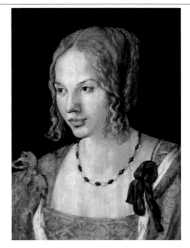

copied his graphics but rejected his art because it was not 'antique',
i.e. it did not conform to the requirements of the Italian Renaissance.
Wealthy Venetians, on the other hand, were keen to keep Dürer in
their city.

His breakthrough came with the *Feast of the Rose Garlands*, a
large altarpiece commissioned by German merchants for their church,
St Bartholomew's. The painting shows the Madonna distributing rose
garlands to a crowd kneeling before her. Although it is now in a
ruinous condition, its unique qualities are still apparent. Stylistically,
it reveals close links with Venetian art, as shown by the lute-playing
angel. What must have made a forceful impression on the artist's con-
temporaries, however, was the individual nature of the faces. The
German king Maximilian, members of Venice's German community
and the artist himself can be recognized. Having thus shown his worth
as a portraitist, he received numerous portrait commissions. In mid-
October 1506, Dürer informed Pirckheimer that he wanted to ride to
Bologna to receive instruction in perspective.

Return to Nuremberg _ Early in 1507, he set out on his return jour-
ney to Nuremberg. He must have had mixed feelings about doing so;
the year before, he had written to Pirckheimer: "How I shall shiver for
the sun. Here I am a gentleman, at home a cadger."

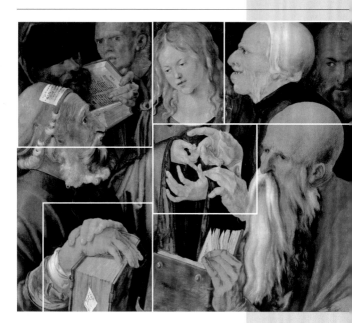

Christ among the Doctors, 1506,
panel, 65 × 80 cm, Museo Thyssen-Bornemisza, Madrid

Christ among the Doctors

Real beauty befits only the true faith _ Dürer's treatment of an Italian genre

Examinations of Dürer's panel paintings have shown that they were made exclusively with oils. The reason for his minimal underdrawing was not an economic one, but rather an expression of his genius as a draughtsman; accordingly, only a few strokes sufficed. The same is true of his application of paint: it was not that his materials were unusual, but his sure use of them was. This presupposes that Dürer knew every time what degree of opacity or transparency he wanted to achieve with his next brushstroke.

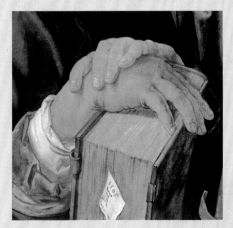

The panel of *Christ among the Doctors* is an *alla prima* work. This means that the artist applied his oils directly to the ground with no underpainting, achieving his finished surface with a single application of pigment. This type of painting has great immediacy and appears almost sketch-like. If one considers that in the artist's time ready-made oils could not simply be squeezed out of tubes, that each pigment had to be laboriously ground and mixed with a medium – obtaining the right consistency of paint, which was an art in itself – Dürer's signature acquires a wholly different value. Full of pride, he has written on the bookmark protruding from the Bible in the foreground on the left: *opus cinque dierum* – the work of five days. Even if Dürer produced the painting quickly, here too he did not dispense with painstaking preparatory studies. Yet it remains open to question whether they were also produced over the same five days as the painting.

Dürer was obviously attracted to hands. Time and again in his sketches, we find detailed studies of hands gesturing and in motion. They play a notable role in conveying the meaning of *Christ among the Doctors*, too.

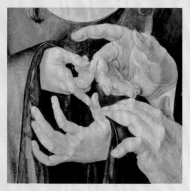

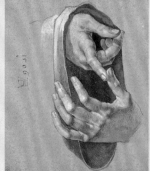

Emphasized by the fall of the light, the hands of the young Christ appear at the centre of the panel. In a tradi-

Hands of the 12-year-old Christ, 1506, pen and ink, 20.7 × 18.5 cm, Germanisches Nationalmuseum, Nuremberg

tional rhetorical gesture of counting the points of his argument, the hands of the young preacher lend the expressive power he needs to convince the old doctors of the validity of his statements.

The painting's composition is unusual, like a close-up. Tightly packed half-length figures fill the panel; almost nothing of the dark back-

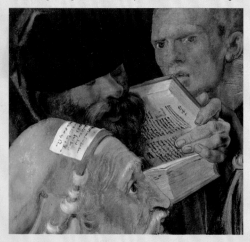

ground can be seen. Dürer dispenses with any narrative detail in his depiction of this meeting, which is described in the Gospel according to Luke. No temple or church indicates the scene of the action, although

the books that dominate the foreground suggest that these are the doctors whom Jesus listened to and questioned in the temple: "... and all who heard him were amazed at his intelligence and the answers he gave." (Luke 2, 47)

In this painting Dürer reveals himself to be a master of polemical characterization. Not only is there no indication of place; there is also no clue as to how the discussion will end. Nevertheless, the viewer is not left in the dark: the figures are clearly characterized. The youthfully attractive Christ, whose angel-like features can be compared to those of the lute-playing angel in the *Feast of the Rose Garlands*, is surrounded by ugly, old and even demonic-looking figures. While the old men, grimacing like caricatures, crowd round him, Christ remains unassailable thanks to his true faith.

In this composition of half-length figures, Dürer employs the visual idiom of his Venetian contemporaries. With the stark juxtaposition of beauty and ugliness, the artist appears to be responding to a demand made by Leonardo da Vinci in his essay *Treatise on Painting*.

The Artisan and the Artist

Commissions for large-scale paintings _ Dürer was back in Nuremberg at the beginning of February 1507. During his absence, his wife Agnes and his mother had kept the graphic art side of the business running. Records show that Agnes travelled to Frankfurt am Main to sell her husband's prints, while his mother sold them at the fair in Nuremberg during the annual exposition of holy relics. Even if in his letters from Venice Dürer mentioned money, and more especially the lack of it, he did not return home a poor man: he had sufficient earnings from his Venetian commissions. In Nuremberg, he promptly made a start on his next large-scale commissions for paintings. In his *Adam and Eve* panels of 1507, the artist elaborates masterly fashion on his 1504 engraving of the same subject. The pair is infused with such vitality that they would appear to move around at will in the pictorial space; all ties with antique statuary have been severed and Dürer has drawn their outlines freely rather than resorting to a geometrical construction. He capitalizes here on what he had learned in Italy and, without resorting to obvious rules, embraces the spirit of Antiquity. It is unknown who commissioned these panels, but in the treatment of the figures, they are every bit the equal of Italian Renaissance art.

> "*On his return to Italy, he was greeted by the artists of Venice and Bologna as a second Apelles.*"
> Christoph Scheurl, 1508

Just as he was completing *Adam and Eve*, he received two more commissions that over the next two years took up so much of his time that he barely managed to do any other work. Although Lucas Cranach the

The artist confidently tells us who painted the picture

Adoration of the Trinity (Landauer Altarpiece) (detail), 1511, limewood, 135 × 123.4 cm, Kunsthistorisches Museum, Vienna

Adam and Eve, 1507, pine, each panel 209 × 81 cm, Museo Nacional del Prado, Madrid

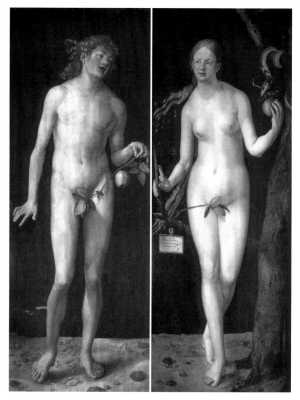

Elder was his court painter, Frederick the Wise, Elector of Saxony, commissioned Dürer to paint a picture for the relic chamber in the palace chapel at Wittenberg. Around the same time, the Frankfurt merchant Jakob Heller asked him to produce a winged altarpiece.

In August 1507, Dürer wrote apologetically to Heller, explaining that he had a temperature and was still busy working on the Elector's time-consuming painting, hence the delay in starting his own commission. With its numerous small figures and intricate landscape setting, *Martyrdom of the Ten Thousand* for Frederick the Wise kept Dürer busy until well into 1508. On hearing of the death of his dear friend Conrad Celtis, the artist included his likeness, alongside his own, in

the painting as further witnesses to the martyrdom of ten thousand Christian warriors on Mount Ararat.

The central panel of the *Heller Altarpiece*, which was finally completed in 1509, was unfortunately destroyed by fire in 1729. Nevertheless, its unusual treatment of the Virgin's coronation has come down to us thanks to a copy made by Jobst Harrich. Dürer leaves the centre of the painting empty, offering us a vista of wide, open country where he stands alone, holding a cartolino bearing his name. The eighteen extant studies for this work give an impression of the care with which Dürer prepared his paintings: every detail was first worked out in a drawing, which explains why hardly any pentimenti are found in

Dürer and Conrad Celtis as witnesses of a biblical event

Martyrdom of the Ten Thousand, 1508, transferred to canvas, 99 × 87 cm, Kunsthistorisches Museum, Vienna

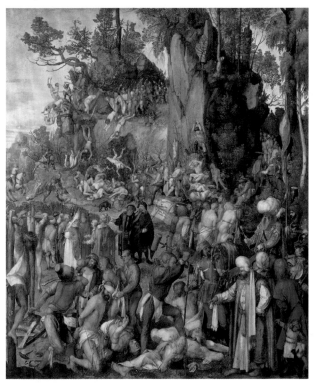

his panel paintings. One of his preparatory studies has become particularly famous: *Study for the Hands of an Apostle* – or *Praying Hands* – has become a popular symbol of piety and is now almost overused on cards bearing congratulations or condolences.

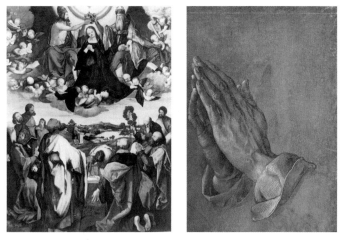

Dürer received his next large commission in 1508. Matthäus Landauer requested him to paint an altarpiece for the chapel in the House of the Twelve Brothers, an almshouse he endowed for the care of elderly artisans. Dürer immediately executed a study for his painting the *Adoration of the Trinity* and its richly carved frame showing Christ and the Last Judgement. Completed in 1511, it formed a unity both as a work of art and in terms of its content. It is all the more regrettable that the frame is now in Nuremberg and the painting in Vienna.

Civic honours and a home at the city gates _ The family's financial position improved greatly during these years and at Easter 1509 Dürer finally received civic recognition. In Italy, he had expressed his regret at not receiving any. Things now changed and he was elected a member of the city's Grand Council, its administrative body.

In June that year, he bought the house at Tiergärtner Tor and, besides the purchase price of 275 florins, was able within a few months to pay off the debt on his house in a single payment. Soon thereafter, he finally received his first official commission for a painting from the city of Nuremberg. The two vertical-format portraits of the Emperor for the relic chamber were completed no later than 1513.

Exchanging work with Raphael — It was around this time that Dürer began to exchange work with the Italian painter Raphael. In return for Dürer's self-portrait, the Nuremberg artist received a nude drawing. The work of both men shows that they inspired each other.

Not only the painting was created by the artist but also the elaborate frame

Adoration of the Trinity (Landauer Altarpiece), 1511, limewood, 135 × 123.4 cm, Kunsthistorisches Museum, Vienna

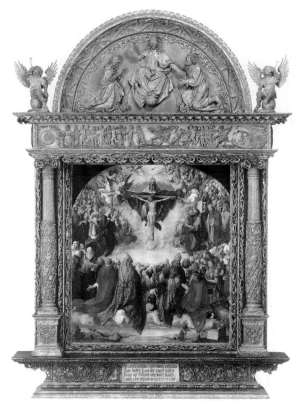

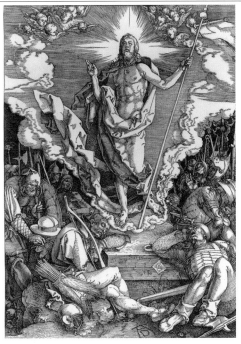

Resurrection of Christ
(Large Passion), 1510,
woodcut, 39.1 × 27.8 cm

Dürer's final commissions for paintings seem to have been less time-consuming because he apparently found enough time to devote himself once again more intensively to graphic art and theoretical studies. He had the idea of publishing a textbook entitled *Ein Unterricht der Malerei* (Instructions in Painting) and, as a poetic sub-title, chose *Speis der Malerknaben* (Nourishment for Young Painters).

> *"Apelles was assisted by colours even though they were fewer and less ambitious. Although Dürer is to be admired in other respects, what doesn't he express solely in monochromes, that is in black lines? Shadow, light, radiance ..."*
> Erasmus of Rotterdam, 1528

Completion of the "Three Great Books" _ Dürer's graphic art experienced a highly creative period around 1510. The artist returned to his series of woodcuts on the *Large Passion* and *Life of the Virgin*,

for which he had first produced sheets around 1500. In 1511, he published these large-format engravings in book form with an explanatory text by the Nuremberg Benedictine Chelidonius. Dürer himself linked them with his 1498 *Apocalypse* series by describing all three as the "Three Great Books". Also in 1511, he published another series on Christ's passion, comprising thirty-seven sheets, whose format, about 13×10 cm, gave rise to the name *Small Passion*. Besides woodcuts, he devoted himself to engraving, albeit to a lesser extent. In 1513, he completed the so-called *Engraved Passion* that he had started in 1507. Together these series represent the pinnacle of Dürer's work as a graphic artist. His greatest achievement, especially in his woodcuts, lay in the light effects produced by his virtuoso modelling. Yet, in his invention of imagery, too, Dürer shows that he lived up to his own principles:

> *"For a good artist has a store of images inside him and, if he were able to live forever, those inner ideas of which Plato writes would always give him something new to express through his work."*
> Dürer, *Lob der Malerei* (In Praise of Painting), 1512

... was produced using the woodcut technique

Last Supper (Small Passion), *c.* 1508/09, woodcut, 12.6 × 9.8 cm

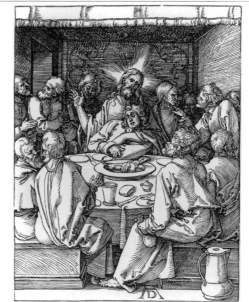

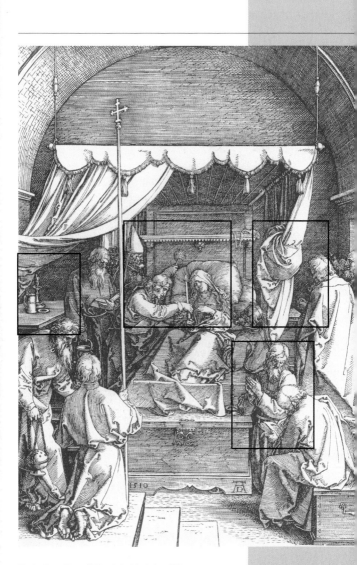

Birth of the Virgin (Life of the Virgin), *c.* 1503,
woodcut, 29.8 × 21 cm

Death of the Virgin

Mary's death in Nuremberg _ The master of the emotionally charged portrayal

Among Dürer's major series of woodcuts, *Life of the Virgin* is certainly the most famous. Its 20 sheets, showing scenes from the life of the Virgin, were produced between 1502 and 1511, with a lengthy break from 1505 to 1510. Particularly in his late woodcuts, the artist perfected a technique whereby the hatching lends his backgrounds a medium tone. The light tone of his paper is left only where it is needed to suggest the fall of light and to emphasize important details. In Death of the Virgin, in which the light clearly comes from the right at the front, this technique increases the sense of spatial depth. Stylistically, the compositions develop from detailed spatial constructions and landscapes to clearly and harmoniously structured visual narratives that highlight the major events of the Virgin's life. If we compare the prints *Birth of the Virgin* and *Death of the Virgin*, two scenes played out in a similar room, it readily becomes apparent that the latter concentrates more on the story being told.

Besides the Gospel according to Luke, which describes Christ's childhood, the main text source for the life of the Virgin and its visual representation is the Apocrypha, those biblical writings that do not form part of the accepted canon of Scripture. Their imagery and contents were familiar to Dürer's contemporaries.

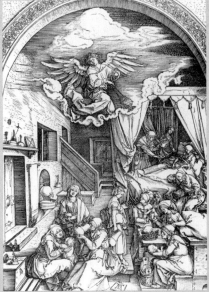

Death of the Virgin (Life of the Virgin), 1510, woodcut, 28.8 × 20.6 cm

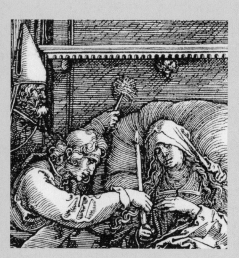

What lends Mary's story its special quality and what contributed to her great popularity was her combination of divine grace as the mother of Christ and her humanness. She inspired emotive portrayals, for instance of the relationship between mother and child. In his *Life of the Virgin*, Dürer the narrator alludes to reality by reproducing the seemingly banal and everyday. He sets the biblical tale in his own time and surroundings to allow viewers to identify with the action.

In the artist's time, many people died at home and everyone knew the preparations needed for the final journey: confession, last communion, extreme unction and prayers offered for and by the dying. Mary lived a life of solitude and when news of her approaching death was brought to

her, she expressed a wish for the Apostles to be present at it. They hurried from all over to gather round her deathbed to administer the sacraments. John here proffers her a candle. Identified as the first bishop of Rome by his pontiffs, Peter sprinkles Mary with holy water while another Disciple reads the last rites. In the foreground, another two Disciples pray for the mother of God on her deathbed.

Dürer sets the scene in a typical Nuremberg patrician home. Individually, the details are depicted realistically, yet the effect they produce when seen as a whole is unreal indeed. The large, four-poster bed and the chests were typical items in sixteenth-century bedchambers. Even the way in which the curtain is tied back in a knot is portrayed realistically, although we cannot see how the curtain on the left is held back. Rather than being intended as a lifelike detail, the composition of the brightly lit, swept back material dramatically emphasizes the group of Apostles in the background.

It allows us a view not only of the Disciples but also of a lidded tankard, a candlestick and a plate atop a chest pushed back against the wall. Although these were items of everyday use found in every household, they are probably included in this context not merely as decorative elements. They may indicate that Mary has already received the last communion. With Mary as its focal point, Dürer's composition, despite its numerous figures, radiates a sense of peace in keeping with the event.

Imperial Representation and Scientific Interest

The Emperor's commission _ Mapping Heaven and Earth, and
the Rhinoceros _ New developments in painting _ Portraits
for posterity

The Emperor's Commission _ From 1512 to 1519, Dürer's creativity served the Emperor's representational needs. The last visit to Nuremberg of Maximilian I and his historiographer Johann Stabius, in February 1512, marked the beginning of Dürer's involvement in the Emperor's numerous artistic projects. Dürer submitted designs for some of the monumental statues of Maximilian's tomb in Innsbruck's Hofkirche; additionally, he illustrated the so-called *Fechtbuch*, Pirckheimer's translations into Latin of Horapollon's *Hieroglyphica* and parts of *Freydal*, a romance describing Maximilian's exploits at tourneys and pageants. *Triumphal Arch* and *Triumphal Procession* were the Emperor's largest commissions and Dürer played a large part in their realization along with other artists, such as Albrecht Altdorfer, Hans Burgkmair, Hans Schäufelein, Hans Springinklee and Wolf Traut. *Triumphal Arch* is a huge woodcut: made up of 195 blocks printed on thirty-six sheets, its mounted dimensions are 3.41 × 2.92 metres. Intended to illustrate the glory and claim to power of Maximilian I and the Habsburg dynasty for evermore, its programme was devised by the Emperor himself in collaboration with Johann Stabius. An overall design by the court painter in Innsbruck, Jörg Kölderer, already existed and Dürer and his colleagues worked to it. Their designs were completed in 1515, but the first printing of 700 was postponed until 1517 for financial and personal reasons. Come July 1515, Dürer had been working for the Emperor without payment for three years, and he asked Stabius to intervene. Maximilian initially offered the artist tax exemption in place of a fee, but then finally arranged payment to him

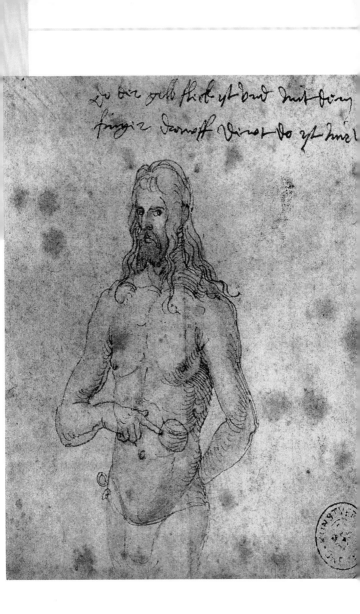

The artist is easily recognisable in this quick sketch

Dürer as a Sick Man, *c.* 1519, pen and ink, 11.8 × 10.8 cm, Kunsthalle Bremen, Bremen

Triumphal Arch of Emperor Maximilian I, 1515, woodcut, 341 × 292 cm

Hours of Emperor Maximilian I, folio 45 recto, 1515, pen on parchment,
Bayerische Staatsbibliothek, Munich

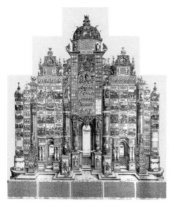

in the form of a lifelong annuity, which was paid only irregularly,
however. Around the same time, Dürer completed the marginal illus-
trations in Maximilian's personal prayer book. Besides Altdorfer,
Baldung, Breu, Burgkmair and Cranach, he had received the lion's
share of the illustrations to do. Executed in green, red and violet ink,
its drawings combine humorous scenes with symbolic representations
of the prayer book's teachings intertwined with elegant arabesques.

In addition to these mainly decorative commissions, Dürer worked
on further improving his skills as an engraver. In 1513/14, he produced
three sheets that are unsurpassed in their mastery: *Rider (Knight,
Death and Devil)*, *St Jerome in his Study* and *Melencolia I* (see p.
47 ff). These works are known collectively as his 'master engravings'
because of their technical excellence and complex subject matter.

Mapping Heaven and Earth, and the Rhinoceros _ That Dürer
was not only interested in the astrological-philosophical speculations
of the humanist scholar Marsilio Ficino, but equally attached to the
natural sciences is shown by some of the woodcuts he produced in
1515. While the map of the world he designed for Johann Stabius hard-
ly reflects the latest discoveries from the circumnavigation of the Cape
of Good Hope, Columbus's first journey to America or Vespucci's ex-
pedition to the east coast of South America, it is nonetheless a mile-

Emperor Maximilian I (1459–1519) _ Although
the coffers of Emperor Maximilian I were constantly depleted, he
was able to enlarge the Habsburg Empire by military expansion
and marriage. Moreover, he gathered the greatest artists of the
day around him at court, where like none of his predecessors he
took a personal interest in his *memoria*. On account of his wide
learning as well as his courtly and chivalrous lifestyle, history has
awarded him the epithet "the last knight". Unusually, he did not
entrust his extensive and partly biographical writings, such as
Theuerdank or *Weisskunig*, to his historiographers, but conceived
them himself. He was also closely involved in the planning of his
largest commissions, *Triumphal Arch* and *Triumphal Procession*,
which Dürer, among others, helped to realize.

stone in the history of cartography because it was the first map of the
world projected, as it were, on to a sphere. In reproducing his image
of the Earth as a flat sphere, Dürer presumably made use of the aids
recommended in his scientific-mathematical treatise *Die Unterweisung
der Messung* (Treatise on Measurement) on how to reproduce three-
dimensional objects using accurate perspective.

Dürer acquired considerable renown in scientific circles with one of
his most famous animal images, the *Rhinoceros* of 1515. Reproduced in
a widely circulated pamphlet, it was a product of his imagination based

... and science

Rhinoceros, 1515, woodcut, 23.5 × 30.2 cm

Johann Stabius's Map of the World, 1515, woodcut, 64.5 × 85 cm

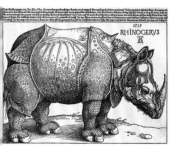
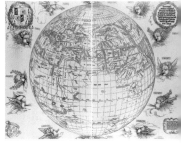

on a description of the beast and fed his contemporaries' desire for sensation. It was the standard illustration in natural history books until the mid-eighteenth century.

New developments in painting _ If Dürer had had to devote himself almost exclusively to graphic art over recent years because of the large-scale commissions he received from Maximilian I, he began to produce paintings again after 1516, initially idealized portraits of the Apostles on canvas. That same year, he painted the portrait of his eighty-two-year-old teacher, Michael Wolgemut. It was not Dürer's

A portait of a head of state – for the first time as a woodcut

Emperor Maximilian I, *c.* 1519, woodcut, 41.1 × 32 cm

Emperor Maximilian I, 1519, limewood, 74 × 61.5 cm, Kunsthistorisches Museum, Vienna

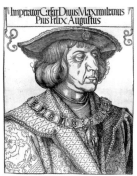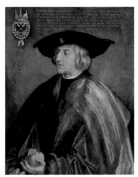

aim to present an idealized image of him; just as he had done in the portrait of his aged father, he was painstaking in his efforts to reproduce the man's features and to convey his personality.

Following Dürer's return from Italy and as a result of his study of perspective, a change in his compositions is apparent. Whenever possible, he now limited the number of figures included and increased their monumentality in a way previously unknown in German art. This development was reflected both in his portraits and devotional paintings, which acquired characteristics similar to those of portraits. In both cases, he strove to simplify his forms, his preference being for the half-length figure or the bust. He created the impression of space solely through the plasticity of his figures. By focusing on the head and the hands, he was able to devote his whole attention to individual treat-

ment and characterization, a principle he realized fully in his 1519 painting *Virgin and Child with St Anne*. In its economy of means and enhanced by its harmonious colouring, the composition of the two women with the Christ Child – his wife Agnes having modelled for the figure of St Anne – radiates a sense of peace that invites contemplation in the viewer.

Portraits for posterity _ The portrait in Dürer's work took on another feature in 1518. Together with a number of councillors, he travelled to the Imperial Diet of Augsburg as a representative of Nuremberg. While it is possible that he was to make a record of the occasion, the highest dignitaries certainly asked him to paint their portraits. Among others, he produced a drawing of his long-time patron Maximilian I, which he based three additional works on: two painted portraits and a woodcut portrait. In the painted portraits, Dürer dispensed with the usual emblems of power, such as the Imperial coat of arms showing the Habsburg crown or the chain of the Order of the Golden Fleece. Instead, he succeeded in creating a state portrait solely through the work's formal composition and the characterization of the sitter. Opinions differ about the woodcut portrait: was the driving force behind it Maximilian himself, who was well aware that graphic art circulated widely and was a popular medium, or was the initiative for this first monumental woodcut portrait in European art Dürer's own? In any case, it went on to become a bestseller.

An economy of style leads to a more intense emotional expression

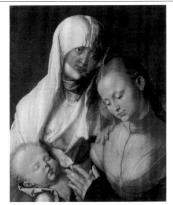

Virgin and Child with St Anne, 1519,
transferred to canvas, 60 × 49.9 cm,
The Metropolitan Museum of Art, New York

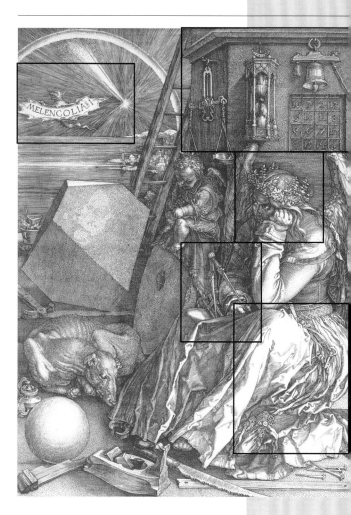

Melencolia I, 1514, engraving, 23.7 × 18.7 cm

Melencolia I

When genius becomes a burden _ The humanistic image of the creative artist

This engraving, one of the so-called 'master engravings', is probably Dürer's most famous. Like no other, it has been interpreted any number of ways, not only by art historians, but also by writers, philosophers, doctors, botanists, mathematicians, astronomers and esoteric figures as well as all those who believed they had finally found a valid explanation of its secrets. The wealth of literature makes it almost impossible to look at this masterpiece objectively. On account of its technical precision, its format and its equally complex subject matter, this work, produced in 1514, around the same time as *Rider (Knight, Death and Devil)* and *St Jerome in his Study*, is thought to form a unity with the other two.

A complex image, its full meaning cannot be grasped at first glance. Yet, the artist helps us out by giving his print a title. On the wings of a bat-like creature flying above a typical Dürer landscape with houses by the waterside is written the word "MELENCOLIA I". The female figure at the centre occupies almost one-third of the print. She sits pensively upon a low stone step, her head resting on her hand.

Dressed in the outfit of a Nuremberg housewife, she bears the insignia of domestic power, a bunch of keys and a pouch of money. Yet at no point does the thought occur that this might be one of Dürer's neigh-

bours! Her mighty wings immediately transport her to other-worldly spheres; her shining eyes gaze pensively into the distance and with the numerous objects surrounding her, only one conclusion can be drawn: this is a personification, a symbol.

Even without the title, the woman's dark face in itself would suggest melancholy, a term derived from the Greek word *melaina* (signifying 'black bile'). Ancient Greek physicians believed that a person's physical and mental qualities were determined by four main bodily fluids and the relative proportions in which they occurred in the body. This gave rise to the idea that there were four basic temperaments: sanguine, phlegmatic, choleric and melancholic. Medieval philosophy adopted this model and expanded it to include the planets, the four elements, the stages of life, the four seasons and winds as well as particular animals and colours. Melancholy's negative associations – gloomy, lazy, mean and unsociable – were rein-

terpreted by the humanist Marsilio Ficino, who based his argument on the views of Aristotle, who had observed that the most intellectually outstanding individuals were often melancholics. Ficino concluded from this that melancholy could actually be a positive, stimulating condition in theologians and artists.

This is a creative and intellectual Melancholy as identified by the many objects surrounding her. Since Antiquity, a pair of compasses has been a symbol both of architects and geometry, one of the seven liberal arts; the book speaks for itself; the hammer, nails and spirit level are references to the trades, while the crucible and syringe hint at some kind of scientific or alchemical activity. The objects in the upper right-hand corner of the print – a balanced pair of scales, a half-expired hourglass, a bell with its clapper hanging silently and a magic square – are the embodiment of this special moment of equilibrium characterized by the right measure and the right number.

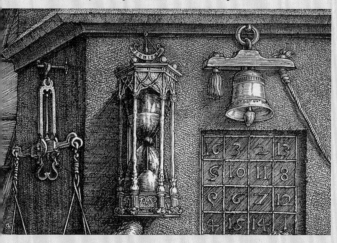

Erwin Panofsky's proposition that *Melencolia* was in a sense "Albrecht Dürer's intellectual self-portrait" remains undisputed. The sum of the magic square's vertical, horizontal and diagonal rows affords a clue: it is always 34, a figure that when reversed makes 43 – the artist's age in 1514. The two numbers in the centre of the bottom row also indicate the year the engraving was produced.

The Reformation and the Theory of Art

Journeys to the Low Countries _ Following the death of Maximilian I, Dürer was keen to have the sovereign's nephew and successor, Charles V, authorize the annuity that the late Emperor had granted him. On 21 July 1520, he set off for the Low Countries where the Emperor had been in residence since early June. Thanks to the diary that Dürer kept from the beginning of his journey until his return home via Cologne in July 1521, this is the best-documented period of his life. We know that the route he took was by ship down the Main and Rhine rivers to Cologne with his wife and maid; from there they travelled overland to Antwerp, from where again they travelled to Aachen, Cologne, Bruges, Ghent, Mechelen and Brussels. Wherever he went, he was received with great honours. He met the leading artists and scholars of the day, including Lucas van Leyden, Conrad Meit, Joachim Patinir, Sebastian Brant and Erasmus of Rotterdam, whose portrait he made twice.

Dürer's journey to the Low Countries must have been highly inspiring for him: besides the many activities that he described in his diary, his artistic output was unbelievably prolific. While on this trip, he drew about 150 portraits and produced six oil paintings, including one of St Jerome joined in his study by the artist's 1514 image of Melancholy. The remarkable success this work enjoyed – around forty largely free copies of it are extant – is surely due to the way it equated Jerome, a Father of the Church and first faithful translator of the Old and New Testaments, with Luther.

Gifts and diseases _ In his diary, Dürer reveals himself to be a sociable man, forever exchanging gifts with others, and he delights in describing the gifts and invitations he received in return. He took an

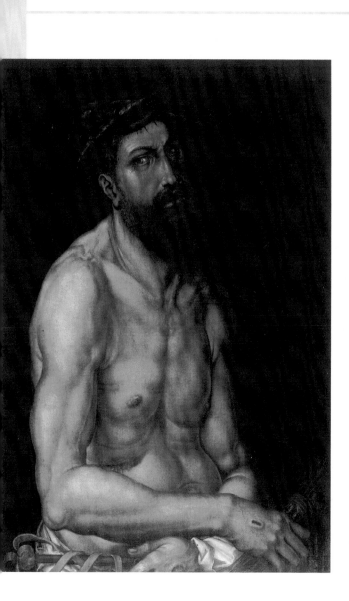

Modelled on himself

Copy after Dürer, **Christ as the Man of Sorrows**, limewood, 86 × 59 cm,
Schloss Pommersfelden, Weissenstein

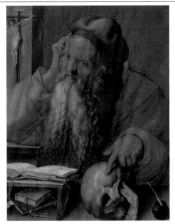

St Jerome, 1521, oak, 59.5 × 48.5 cm,
Museu Nacional de Arte Antiga, Lisbon

interest in all kinds of attractions in Brussels, such as the Aztec treasure that Hernán Cortés had presented to the Spanish king, Charles V, and the royal zoological garden, where he made sketches.

In one case, Dürer's thirst for knowledge was to have serious consequences, however: in December 1521, while on one of his outings, he caught what would appear to have been malaria. The disease was to recur throughout the rest of his life.

Effects of the Reformation _ While Dürer was still in the Low Countries, news reached him that Frederick the Wise had had Luther arrested. The artist's famous lament for him shows that he was unaware that the Reformer had been arrested for his own protection: "Oh, God, is Luther dead? Who henceforth is to expound to us the holy Gospel with such clarity!" (Dürer, *Diary in the Low Countries*, 1521) Dürer became aware of the Reformer's views at an early stage through his contact with humanist circles in Nuremberg. He acquired his writings wherever possible and expressed the desire to make an engraving of Luther, a wish that regrettably went unrealized.

There has been much speculation about how Dürer's stance towards the Reformation changed, especially after the radicalization of the movement that first took hold in Wittenberg and whose effects were felt in Nuremberg, too. Given that he cites Luther's writings on the question of the religious use of images in his foreword to *Die*

Erasmus of Rotterdam (1469-1536) _ The most
renowned humanist of the Reformation, Erasmus of Rotterdam
championed a renewal of Christianity, but without Luther's
extremism. The culmination of his academic career was the publi-
cation in 1516 of the original Greek New Testament on which
Luther based his Latin translation. He realized early on that his
reputation could not rest on intellectual correspondence and pam-
phlets alone, and adopted the portrait as his own form of propa-
ganda. Choosing St Jerome as his model, he deliberately had his
portrait executed in the style associated with the saint, leaving
artists little freedom of their own. Dürer's engraving also depicts
him as the 'New Jerome'.

Unterweisung der Messung, it may be assumed that Dürer continued
to value Luther's moderate views and did not support iconoclasm.
Last works _ Back in Nuremberg, Dürer was busy with designs for
a large sacra conversazione, a representation of the Virgin and Child
with Saints all in one scene rather than in the separate compartments
of a polyptych; unfortunately, it was never executed. Over the next
few years, he produced only a few paintings, mostly portraits. His
principal task was the completion of the *Four Apostles*, a striking
work done in the last years of his life. In 1526, Dürer bequeathed the
two panels to Nuremberg "so that I might be remembered."

Dürer's enthusiasm for the world around him is mirrored in his drawings

Studies with Sketches of Animals and Landscapes, 1521, pen and black ink with coloured washes, 26.4 × 39.7 cm, Sterling and Francine Clark Art Institute, Williamstown

Around this time, Dürer again focused on producing drawn and engraved portraits. He developed a basic template of a half-length figure in profile with inscriptions, and modified it to reflect the personality of his sitter. His 1524 engraving of his friend Willibald Pirckheimer fol-

The ultimate humanist portraits of two scholars

Willibald Pirckheimer, 1524, engraving, 18.1 × 11.5 cm

Erasmus of Rotterdam, 1526, engraving, 24.7 × 19 cm

lowed this template, and it later became the prototype of the humanist portrait. Dürer's engraved portrait of Erasmus – finally executed in 1526, after repeated reminders from the humanist scholar – did not follow this template, however. The only portrait of its kind at the time, it shows the sitter in the background engrossed in some task. It is possible that Erasmus himself asked for his study to be shown with the focus on his books in the foreground as references to his profession.

Major theoretical writings _ Dürer's artistic output dwindled slightly after his journey to the Low Countries, but this was partly due to the work involved in producing the final draft of his theoretical manuals and seeing to their printing. In 1523, he postponed publication of his work on proportions, which had almost been ready for press even before he set off on his trip. He was concerned that the book would not be understood and, in 1525, published his *Die Unterweisung der Messung* as the theoretical basis of his work as an artist. In it, he explains the rudiments of geometry and how artists and craftsmen can apply them in their work. In 1527, he published his *Befestigungslehre* (Treatise on Fortification), a subject that was not unusual among Renaissance artists as many of them took an interest in architecture and fortification. A manual of this sort was sufficiently topical given the threat of Turkish invasion. It looked as if Dürer was ready to publish his treatise on proportions the following year. The first of the *Vier Bücher von menschlicher Proportion* (Four Books on Human Proportions) – which together with the theoretical writings of Leonardo da Vinci are among the most important Renaissance contributions to the theory of art – was proofread by Dürer himself, although he did not live to see the publication of the whole work on 31 October 1528.

Death of a genius _ Albrecht Dürer died on 6 April 1528 shortly before his fifty-seventh birthday. Pirckheimer's epitaph to him read: "Whatever was mortal of Albrecht Dürer rests beneath this grave."

The teacher Dürer – his knowledge should help generations to come

Draughtsman Drawing a Lute, 1525, from Unterweisung der Messung, woodcut

Man of Eight Head-Lengths, 1528, from Vier Bücher von menschlicher Proportion, woodcut

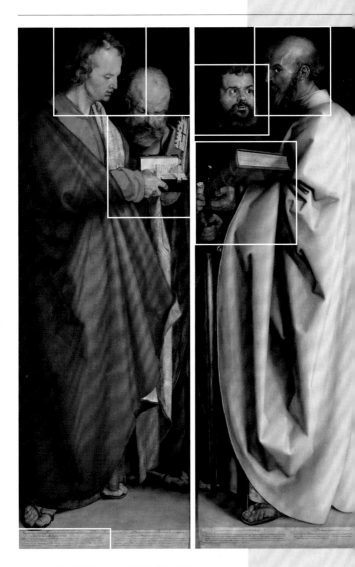

Four Apostles, 1526, limewood, 212.8 × 76.2–75.9 cm,
Bayerische Staatsgemäldesammlungen, Munich

Four Apostles

Is Luther here? _ Dürer's own confession of the true faith

Dürer painted the two panels of the *Four Apostles* in 1526 and donated them to Nuremberg's Grand Council 'that I might be remembered', as he stated in his letter. The picture hung in the Town Hall until Elector Maximilian I claimed it for himself in August 1627. The Council at first refused, but eventually relented and sent the paintings to Munich along with copies. It hoped that 'the Jesuits of Munich' would reject the works' Protestant inscriptions and return the originals. The Elector – a true devotee of Dürer – simply had the inscriptions sawn off and re-turned them with the original frame and the copies. The panels, inscriptions and original frame were not reunited until 1922.

While its meaning is easily grasped at first glance, this diptych of Saints John, Peter, Mark and Paul has occasioned much debate. The very fact that Dürer produced it voluntarily and donated it to Nurem-berg's Grand Council lends it special significance that is further enhanced by the injunction to secular rulers in such dangerous times not to be led astray by mistaking human words for the voice of God. The wording has been read repeatedly as Dürer's religious legacy and attempts have been made to deduce from it his attitude towards Luther and the Reformation.

The title the panels have borne since 1538 – the *Four Apostles* – is slightly misleading and convincing explanations have been sought. There are in fact only three Apostles, Mark being an Evangelist. Was Dürer trying to achieve a counterbalance between the Apostles – Peter, Paul and John – and the Evangelist? The key to his choice of subjects evidently lies in the books they hold in their hands. John and Mark are each shown with their Gospel in the form of a scroll and an open Bible. Paul, too, carries a book that is given greater prominence in the

foreground and that almost supplants the sword, the attribute for which he is better known. Dürer chose these four saints because of their writings that warn of false teachers, give advice on how to recognize good preachers and inveigh against the arrogance of the doctors.

As this painting was believed to be an expression of Dürer's view of the Reformation, repeated attempts have been made to identify the Apostles as portraits. The image of Mark, for instance, has been seen as a portrait of Luther in the way that Cranach depicted him as Junker Jörg. The only portrait that can be identified with any degree of certainty is that of Philipp Melanchthon in the guise of John. Melanchthon was a German humanist and reformer who stayed

in Nuremberg in
1525/26, when Dürer
drew his portrait
and later made an
engraving from it. On
closer examination,
however, it becomes
apparent that the
similarity is merely
one of type. As much
as the others, John
fits in to the visual

canon that had evolved in
Christian art. Paul's head is
clear proof of this: it had
already appeared in 1506
in the *Christ among the
Doctors*, although here it
is not shown in profile.

Inscriptions in an official-
looking hand lend the pan-
els the character of docu-
ments and clarify their
meaning, while the saints'
monumentality is a visual
affirmation of the appeal
contained in the inscrip-
tions. Who could doubt the
teachings of these steadfast
men? One of the artist's
most intellectual works, the
Four Apostles has become
the symbol of Protestantism.

Where can Dürer's works be seen?

Oxford •
Windsor •
Londo

• Boston
• New York
Washington D.C.

North America

Bayonne •

Madrid •

Lisbon •

Hamburg

Bremen

Amsterdam

Berlin

Brunswick

Dresden

Rotterdam

Kassel

Weimar

Cologne

Schweinfurt

Coburg

Prague

Frankfurt

Bamberg

Darmstadt

Erlangen

Nuremberg

Paris

Vienna

Basle

Munich

Milan

Florence

Key

(**G**): Graphic works: engravings,
 etchings, woodcuts
(**P**): Paintings
(**D**): Drawings

Amsterdam
Rijksmuseum Amsterdam
Rijksprentenkabinet
Jan Luykenstraat 1a
www.rijksmuseum.nl (**G**)

Bamberg
Staatsbibliothek
Domplatz 8
www.uni-bamberg.de/staats-
bibliothek (**G**)

Basle
Öffentliche Kunstsammlung Basel
Kunstmuseum
Sankt-Alban-Graben 16
www.kunstmuseumbasel.ch (**G, P, D**)

Bayonne
Musée Bonnat
5, rue Jacques-Laffitte (**D**)

Berlin
Staatliche Museen zu Berlin
Preußischer Kulturbesitz
Gemäldegalerie Kulturforum
Matthäikirchplatz 4
www.smb.spk-berlin.de (**P**)

Staatliche Museen zu Berlin
Preußischer Kulturbesitz
Kupferstichkabinett Kulturforum
Matthäikirchplatz 4
www.smb.spk-berlin.de (**G, D**)

Boston
Museum of Fine Arts
465 Huntington Avenue
www.mfa.org (G)

Bremen
Kunsthalle Bremen
Am Wall 207
www.kunsthalle-bremen.de (**G, P**)

Brunswick
Herzog Anton Ulrich-Museum
(Kunstmuseum des Landes
Niedersachsen)
Museumstraße 1
www.museum-braunschweig.de (**G**)

Coburg
Kunstsammlungen
der Veste Coburg
Veste Coburg
www.kunstsammlungen-coburg.de
(**G, D**)

Cologne
Wallraf-Richartz-Museum
(Museen der Stadt Köln)
Martinstraße 39
www.museenkoeln.de/wrm/ (**G, D**)

Darmstadt
Hessisches Landesmuseum
Friedensplatz 1
www.landesmuseum-darmstadt.de
(**D**)

Dresden
Staatliche Kunstsammlungen
Dresden
Gemäldegalerie Alte Meister
Theaterplatz 1
www.staatl-kunstsammlungen-
dresden.de (**M**)

Staatliche Kunstsammlungen
Dresden, Kupferstich-Kabinett
Güntzstraße 34
www.staatl-kunstsammlungen-
dresden.de (**G, D**)

Erlangen
Grafische Sammlung der
Universität
Schuhstraße im UB-Altbau (**D**)

Florence
Galleria degli Uffizi
Piazzale degli Uffizi
www.musa.uffizi.firenze.it (**P, D**)

Frankfurt am Main
Historisches Museum
Saalgasse 19
www.historisches-museum.frank-
furt.de (**P, D**)

Städelsches Kunstinstitut und
Städtische Galerie
Dürerstraße 2
www.staedelmuseum.de (**M**)

Hamburg
Hamburger Kunsthalle
Glockengießerwall
www.hamburger-kunsthalle.de (**P, D**)

Kassel
Staatliche Museen Kassel
Gemäldegalerie Alte Meister
Schloss Wilhelmshöhe
www.museum-kassel.de (P)

Lisbon
Museu Nacional de Arte Antiga
Rua das Janelas Verdes
www.mnarteantiga-ipmuseus.pt (P)

London
The British Museum
Great Russell Street
www.thebritishmuseum.ac.uk (G, D)

National Gallery
Trafalgar Square
www.nationalgallery.org.uk (P)

Madrid
Museo Nacional del Prado
Paseo del Prado
www.museoprado.es (P)

Museo Thyssen-Bornemisza
Paseo del Prado 8
www.museothyssen.org (P)

Milan
Biblioteca Ambrosiana
Piazza Pio XI 2
www.ambrosiana.it (D)

Munich
Bayerische Staatsgemälde-
sammlungen, Alte Pinakothek
Barer Straße 27
Entrance: Theresienstraße
www.pinakothek.de (P)

Staatliche Grafische Sammlung
Pinakothek der Moderne
Barerstraße 40
www.pinakothek-der-moderne.de
(G, D)

New York
The Metropolitan Museum of Art
1000 Fifth Avenue at 82nd Street
www.metmuseum.org (G, P, D)

Nuremberg
Museen der Stadt Nürnberg
Albrecht-Dürer-Haus
Albrecht-Dürer-Straße 39
www.museen.nuernberg.de

Germanisches Nationalmuseum
Kartäusergasse 1
www.gnm.de (G, P, D)

Oxford
Ashmolean Museum of Art and
Archaeology
Beaumont Street
www.ashmol.ox.ac.uk (D)

Paris
Bibliothèque nationale de France
58, rue de Richelieu
www.bnf.fr (G, D)

Musée du Louvre
34–36, quai du Louvre
www.louvre.fr (G, P, D)

Prague
Národní galerie (National Gallery),
Sterbersky Palác –
Hradcanské nám. 15
www.ngprague.cz (P)

Rotterdam
Museum Boijmans Van Beuningen
Museumpark 18–20
www.boijmans.rotterdam.nl (D)

Schweinfurt
Bibliothek Otto Schäfer
Museum für Buchdruck, Grafik,
Kunsthandwerk
Judithstraße 16
www.bibliothek-otto-schaefer.de (G)

Vienna
Albertina
Albertinaplatz 1
www.albertina.at (G, D)

Kunsthistorisches Museum
Maria Theresia-Platz
www.khm.at (P, D)

Washington D.C.
National Gallery of Art
Between 3rd and 9th Streets NW
Constitution Avenue
www.nga.gov (P)

Weimar
Kunstsammlungen Weimar
Schlossmuseum
Ehem. Weimarer Residenzschloss
am Burgplatz
www.augentier.de/kusa (G, D)

Windsor
The Royal Collection
Windsor Castle
www.the-royal-collection.org.uk
(P, D)

More about Dürer: a selection of books on the artist and his works

Just as varied as the work of Albrecht Dürer himself is the literature about the artist and his œuvre, although the majority of books are regrettably only available in German.

An outstanding **standard work** that has retained its validity thanks to its thorough scholarship is: Erwin Panofsky, The Life and Art of Albrecht Dürer, 2. vols, Princeton 1943, revised as Life and Art of Albrecht Dürer, Princeton 1948. Ever since its appearance, this work – which is primarily devoted to Dürer the Humanist – has been regarded as the basis of any consideration of Dürer's intellectual achievement.

Catalogues raisonnés include: W. L. Strauss, The Complete Drawings of Albrecht Dürer, 6 vols, New York 1974; W. L. Strauss, Albrecht Dürer: Intaglio Prints, Engravings, Etchings and Drypoint, New York 1975 and W. L. Strauss, Albrecht Dürer: Woodcuts and Woodblocks, New York 1980. The latter is a comprehensive, critical catalogue covering dubious attributions.

A **general overview** of the artist and his times can be found in: Fedja Anzelewsky, Dürer: His Art and Life, London 1980. Other **monographs** include: M. Levey, Dürer, London 1964; P. Streider, The Hidden Dürer, Oxford 1978 and P. Streider, Dürer, revised edition New York 1989.

The Graphic Work of Albert Dürer: An Exhibition of Drawings and Prints in Commemoration of the Quincentenary of his Birth, exhib. cat. (The British Museum), London 1971, and Campbell Dodgson, The Master of Engraving and Etching: Albrecht Dürer, London/Boston, 1926, are sound works of reference covering **specific areas** of Dürer's work.

Well-researched, art-historical material on **different aspects of Dürer's works,** related in an easy-to-read style and accompanied by excellent quality reproductions, can be found in: Fritz Koreny, Albrecht Dürer and the Animal and Plant Studies of the Renaissance, Munich 1985;

Albrecht Dürer: Achtzig Meisterblätter, edited by the Germanisches Nationalmuseum in Nuremberg, Munich et al. 2003; Ludwig Grote, Albrecht Dürer: Reisen nach Venice, Munich et al. 1998 and Victoria Salley, Nature's Artist: Plants and Animals by Albrecht Dürer, Munich et al. 2003.

A direct insight into the artist's way of thinking can be found in his **own writings:** Sir William Martin Conway, Literary Remains of Albrecht Dürer, Cambridge 1889 or Coway's revised work published as The Writings of Albrecht Dürer, with an introduction by A. Werner, New York 1958.

Facsimiles combine graphic perfection with explanatory texts: Das Gebetbuch Emperor Maximilians, Heinrich Sieveking (ed.), Munich et al. 1987; Albrecht Dürer – Die drei grossen Bücher: Marienleben, Grosse Passion, Apokalypse, Anna Scherbaum, Matthias Mende and Rainer Schoch (eds), Nördlingen 2001 and Albrecht Dürer: Die Apokalypse, Ludwig Grote (ed.), Munich et al. 1999.

And for those who would like to share their enthusiasm for Dürer and his art: Albrecht Dürer, Prestel Postcard Book, Munich et al. 2003.

Albrecht Dürer's Self-Portraits

Like no other artist of his day, Dürer was preoccupied with depicting himself and his artistic genius. Besides allegorical works, such as his engraving of *Melencolia I* [see p. 49ff], there are numerous self-portraits in paintings in which he appears as a witness as well as portraits of saints or, indeed, Christ, for which he used himself as a model. These images are a powerful testimony to his personality.

His 1484 *Self-portrait* [see p. 5] still evinces a playful enjoyment in his own artistic abilities. Just how much he valued this silverpoint self-portrait is attested to by the fact that he took great care of it and in later years added the inscription: "This I drew myself from a mirror in the year 1484, when I was still a child. Albrecht Dürer."

In the *Self-portrait* he completed in 1500 [see p. 19], on the other hand, all traces of playfulness have disappeared. It depicts Dürer as a Christian and a humanist who, through the agency of his creative gifts, demonstrates his conviction in the nobility and divine origin of his art. The Latin inscription bears this out: "Albrecht Dürer from Nuremberg. Aged 28 years, I created this portrait in my characteristic colours."

His presence in the *Adoration of the Trinity* (see p. 31) far exceeds what today we would assume to be a proud claim of authorship. Here, Dürer functions as a kind of earth-bound witness to celestial events – a relatively common practice since the fifteenth century.

His pen-and-ink drawing entitled *Dürer as a Sick Man* (see p. 43) is a self-portrait in an autobiographical context. Its inscription has given rise to speculation that it was intended as information for a doctor: "The yellow spot that I'm pointing to is where it hurts."

When he was elaborating studies of saints, Dürer also frequently drew himself, which was certainly an uncomplicated and economical way of going about things. His studies were occasionally taken a stage further to actual paintings that sometimes bear a striking resemblance to Dürer himself, as in his *Christ as the Man of Sorrows*, of which sadly only a copy exists (see p. 53).

Apelles A Greek painter of the second half of the fourth century B.C., Apelles was made court painter to Alexander the Great and was the most famous artist of Antiquity. His skill was legendary and numerous anecdotes are told about it; according to one, his paintings were so realistic that even bees tried to collect nectar from his flowers.

Iconoclastic Controversy The name given to the dispute over the veneration of Christian images, which took place between 726 and 787, after the Byzantine emperor Leo III decreed that all images were idols and therefore should be destroyed. Luther's rejection of the veneration of images led to the destruction of churches in the sixteenth century. He did not incite such action, but it, too, is described as iconoclasm.

Diptych A term, from the Greek meaning 'two tablets', referring to a pair of panels hinged together to open like a book, such as ancient hinged writing-tablets with waxed inner surfaces for writing on with a stylus. In the Middle Ages, two-winged altarpieces without a central panel or accompanying portrait panels were known as diptychs.

Genre painting Works depicting scenes from daily life. Religious subjects are often combined with everyday objects to form a religious genre painting. Dürer was a master of this genre; his *Life of the Virgin* makes compelling use of domestic settings.

Correspondance of St Jerome This describes the life of St Jerome (*d.* 420), who lived as a hermit in the desert where he translated the Bible into Latin. The most famous and frequently told anecdote about him is that of the lion with a thorn in its paw. Jerome removed the thorn and the grateful lion became his constant companion.

Heightening A means of making a colour more luminous or more intense to increase plasticity. Usually hatching or white dots were used while, occasionally, gold can be found.

Woodcut A design carved into a block of wood so that the areas left in relief can be inked and printed onto paper. When Dürer produced woodcuts, he drew directly on the printing block which, as was customary at that time, was then incised into the wood by a specialist cutter.

Line engraving The oldest of the intaglio (incised) printing methods involves the use of a burin, a short steel rod that is usually lozenge-shaped in section and is cut obliquely at the end to provide a point. The line engraver cuts the design directly into the surface of a smooth copper or brass plate. When the plate is inked, the ink collects only in the engraved furrows. As a trained goldsmith, Dürer probably engraved his own plates – a task that was extremely time-consuming.

Oil paint Oil painting is flexible in terms of its rich and dense colours, its wide range from light to dark and its ability to achieve both minute detail and subtle blending of tones. Oils, which usually contain linseed as a binding agent, can be applied to a surface in varying thicknesses – from impasto to porcelain smoothness.

Pentimento Italian for 'repentance', pentimento is the name given to the part of a picture that has been overpainted by the artist but which has become visible again as the overlying layer of pigment has become more transparent with age. Nowadays, x-rays can reveal a painting's original contours.

Veduta Italian for 'view' is the term used to describe a representation of a town or landscape that is sufficiently faithful to allow identification of the location. *Vedute* may be painted, engraved or drawn; above all, they are realistic.

Front cover: **Self-portrait** (detail), 1500, see also front flap and p. 19
Back cover: **Rhinoceros** (detail), 1515, see also p. 45

Photographic credits: cover, pp. 7, 10 r., 19, 23 l., 24, 25, 31, 33, 35, 46r.,
59: Artothek, Weilheim _ pp. 5, 9 r., 22, 34 r.: Albertina, Vienna _ pp. 8 l.,
28 top r.: Germanisches Nationalmuseum, Nuremberg _ pp. 8 r., 23 r.:
Galleria degli Uffizi, Florence _ p. 10 l.: Musée du Louvre _ pp. 12 l., 32:
Museo Nacional del Prado, Madrid _ p. 12 r.: National Gallery, London _
pp. 14, 43: Kunsthalle Bremen, Bremen _ p. 20: The British Museum,
London _ p. 27: Museo Thyssen-Bornemisza _ p. 34 l.: Historisches
Museum, Frankfurt am Main _ p. 47: Metropolitan Museum of Art,
New York _ p. 53: Schloss Pommersfelden, Weissenstein _ p. 54: Museu
Nacional de Arte Antiga, Lisbon _ p. 55: Sterling and Francine Clark Art
Institute, Williamstown

The Library of Congress Cataloguing-in-Publication data is available;
British Library Cataloguing-in-Publication Data: a catalogue record for
this book is available from the British Library; The Deutsche Bibliothek
holds a record of this publication in the Deutsche Nationalbibliografie;
detailed bibliographical data can be found under: http://dnb.ddb.de

Prestel Verlag, Königinstrasse 9, 80539 Munich
Tel. +49 (89) 38 17 09-0; Fax +49 (89) 38 17 09-35

Prestel Publishing Ltd., 4 Bloomsbury Place, London WC1A 2QA
Tel. +44 (020) 7323-5004; Fax +44 (020) 7636-8004

Prestel Publishing, 900 Broadway, Suite 603, New York, NY 10003
Tel. +1 (212) 995-2720; Fax +1 (212) 995-2733

www.prestel.com

Series concept: **Victoria Salley**
Graphics: **www.Lupe.it**, Bolzano, Italy

Editorial direction: **Christopher Wynne**
Translated from the German by **Stephen Telfer**, Edinburgh
Copy-edited by **Michele Schons**, Gröbenzell
Designed and typeset by **zwischenschritt** and **a.visus**, Munich
Originations by **ReproLine mediateam**, Munich
Printed and bound by **Gotteswinter**, Munich

Printed in Germany on acid-free paper
ISBN 3-7913-3075-6